KT-522-070

WILDLIFE *of* AFRICA
GERALD & MARC HOBERMAN

*Photographs in celebration of
the continent's spectacular animal kingdom*

Text by Roelien Theron

THE GERALD & MARC HOBERMAN COLLECTION
CAPE TOWN • LONDON • NEW YORK

Photography and production control: Gerald & Marc Hoberman
Design: Gerald Hoberman, Marc Hoberman, Roelien Theron
Editor: Roelien Theron *Layout:* Christian Jaggers

Mighty Marvelous Little Books are published by
The Gerald & Marc Hoberman Collection
PO Box 60044, Victoria Junction, 8005, Cape Town, South Africa
Telephone: 27-21-419 6657 Fax: 27-21-418 5987 e-mail: office@hobermancollection.com
www.hobermancollection.com

International marketing, corporate sales and picture library

United Kingdom, Republic of Ireland **United States of America, Canada, Asia**
& Northern Ireland, Europe Hoberman Collection (USA),
Hoberman Collection (UK) Inc. / Una Press, Inc.
250 Kings Road, London, SW3 5UE PO Box 880206, Boca Raton, FL 33488, USA
Telephone: 0207 352 1315 Fax: 0207 352 4617 Telephone: (561) 542 1141
e-mail: uk@hobermancollection.com e-mail: hobcolus@bellsouth.net

ISBN 1-919734-53-8

Copyright subsists in this material. Duplication by any means is prohibited without
written permission from the copyright holders. © Gerald & Marc Hoberman 2002

First published 2002, Reprinted 2002, 2003, 2005, 2006

Printed in Singapore

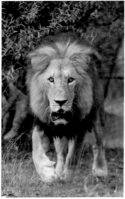

LION *(Panthera leo)*

CONTENTS

What is man without the beasts?
If all the beasts were gone, man would die
from a great loneliness of spirit.
For whatever happens to the beast
also happens to the man.
All things are connected.
Whatever befalls the earth
befalls the sons of the earth.

Chief Seattle, Chief of the Dwamish (1854)

INTRODUCTION

We have seen wondrous things. We have visited some of the remotest places on earth in pursuit of our vision: to capture on film for posterity – and to share with the world – a collection of indelible images of wildlife, each one spectacular, enduring and thought-provoking.

In the course of this odyssey we discovered majesty in mountains, companionship in people and a joy in celebrating nature. The wealth of the vast outdoors and its extraordinary animal kingdom, and their continuity over aeons, seem to us to represent a link with infinity. It is a

profoundly spiritual experience to stand in silent awe of creation, contemplating both our humble insignificance as human beings, and our triumph.

The purity of early morning air has intoxicated our spirits, as has the smell of dust as rain begins to fall on the plains of Africa.

We have marvelled at the sound of silence, revelled in remoteness, peace and tranquillity – and learned to fear them too.

We have been exhilarated by journeys in every kind of transport, from hot-air balloon to helicopter, sea plane and mokoro. On our journeys we have had several

narrow escapes, and have only the grace of God to thank that we are here to tell the tale.

We hope the pictures and the stories behind them will encourage more people to feel connected with, and do their best to conserve, the fast-dwindling natural habitats of the world's diverse and extraordinary fauna and flora.

Our ultimate dream is that all of us so appreciate this bounteous heritage that we do whatever is necessary to preserve it for future generations.

Gerald Hoberman *MHoberman*

GERALD & MARC HOBERMAN
Cape Town

KALAHARI CATNAP

A lion *(Panthera leo)* enjoys a catnap on a grass-tufted Kalahari sanddune. These tawny cats spend most of the day dozing, hunting at night except when prey is scarce. However, when there's a pride of lionesses in thrall male lions rely instead on the females' prowess. Hunting either individually or collectively, lionesses use up to 50 distinct sounds to communicate with each other while coordinating an ambush. After the kill, males are the first to eat their fill, and are then joined by the lionesses and cubs.

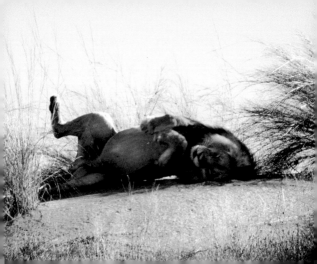

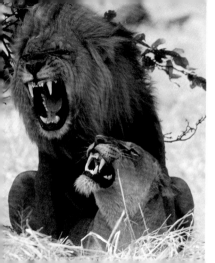

Mating lions
To produce one litter of cubs, lions mate about twice an hour over four days — the duration of oestrus. Only one oestrus period in five results in offspring.

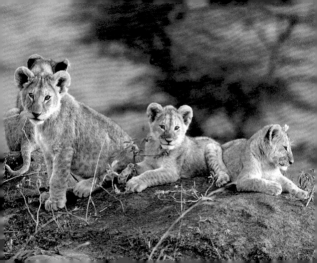

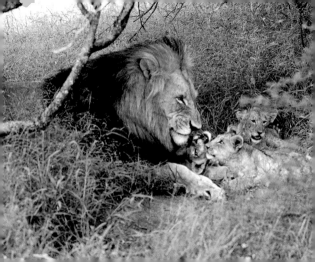

LION AND CUBS

This 'smile' belies the ferocity of moments earlier, when this young male had tried to kill the cubs of his newly conquered pride. This survivor of the battle of the fittest probably sought to propagate his own genes in an attempted act of infanticide – lactating lionesses can't conceive. Two of the lionesses leapt fiercely to the cubs' defence. After a short but serious altercation the lion, suitably corrected by the lionesses, engaged the cubs in a gentle, tender interaction, but with a malevolent 'smile' on his face.

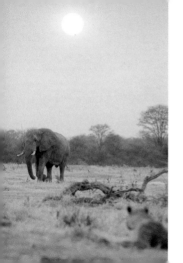

Elephant and lioness
An elephant (Loxodonta africana) and a lioness cross paths as the sun's fierce rays, diffused by a raging veld fire in Savuti, Botswana, cast a pinkish hue. Many regard the elephant as Africa's real King of Beasts.

Right *Elephant calf.*
Overleaf *Elephant herd.*

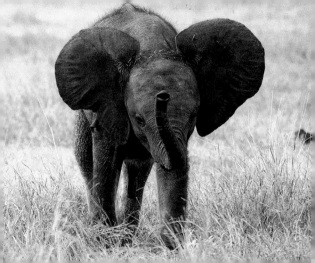

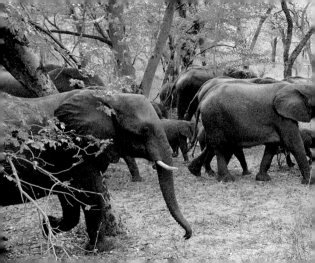

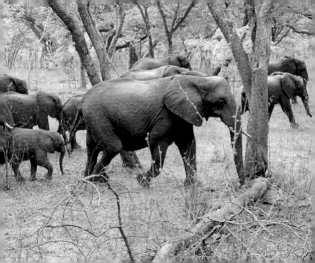

LAKE KARIBA

Water is an essential element of elephants' habitat as they can only exist without it for short periods. While they depend on water to slake their enormous thirst, it also has unlimited recreational possibilities, as these two elephants in Lake Kariba, Zimbabwe, demonstrate. Elephants have also been spotted crossing the Zambezi River, using their trunks as snorkels while en route to the islands in search of food. Elephants and their association with water are well represented in the rock paintings of the San (Bushmen) of southern Africa.

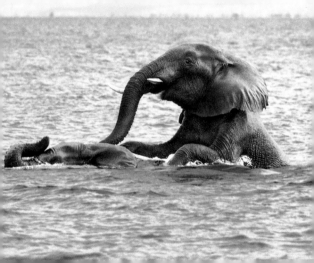

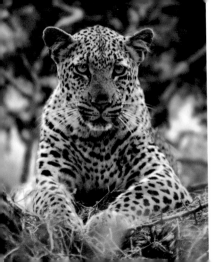

Leopard

Powerful and magnificent, the leopard (Pan-thera pardus) displays great patience and supreme stealth during the hunt, pouncing swiftly before its prey is able to react.

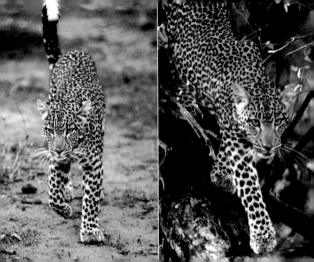

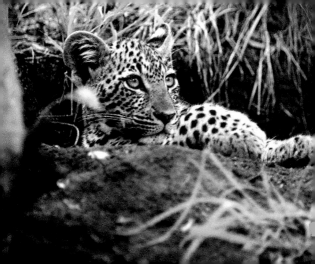

Leopard cub *Cubs are born in secluded places. They are kept hidden for six weeks and moved periodically to a new liar to protect them from predators. Weaned after three months, cubs stay with their mother until they are two years old.*

AFRICAN OR CAPE BUFFALO

Though seemingly docile, the African or Cape buffalo *(Syncerus caffer)* is a most feared member of Africa's 'big five'. While quite placid if unprovoked, it is savage in attack, using its flamboyantly curved horns to hook, toss or gore an assailant. Its only threat is from lions and humans, and the presence of both could provoke a deadly mobbing attack. Both predator and hunter risk being held captive in a tree, or trampled by a stampeding herd. Juveniles as well as injured and diseased adults are preyed upon by lions and spotted hyenas.

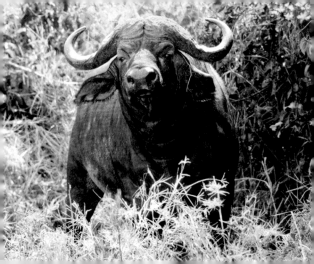

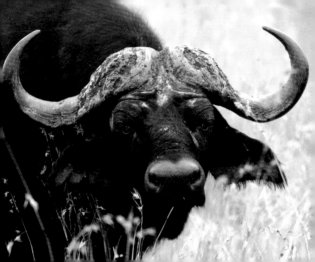

HERD BEHAVIOUR

Buffalo are most abundant where water, grass and shade are plentiful. These large ruminants graze together peacefully in herds of up to 2,000 individuals. Such huge herds need an effective communication and coordination system to maintain the same direction, to defend against predators and to respond to calves' distress calls. Their complex vocabulary includes repeated low-pitched calls to coordinate herd movements, grunts and croaks during grazing to signal that all is well, and a high-pitched croak by the calf when it is separated from its mother.

WHITE RHINOCEROS

The white rhino *(Ceratotherium simum)* takes its name from the Dutch word *wijd*, meaning 'wide'. Although this aptly describes the colossal mammal's muscular, square-lipped jaw, it is not an accurate description of its skin colour. In fact, both the white rhino and its cousin, the black rhino, are grey and tend to display the colour of the mud in which they wallow. Such a bath not only keeps the rhino cool but also creates a mud barrier on the skin's surface that helps suffocate ticks and prevents insects from laying eggs.

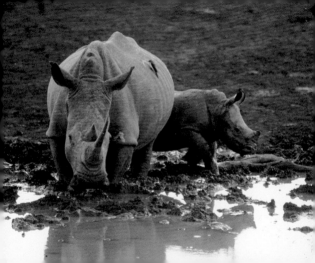

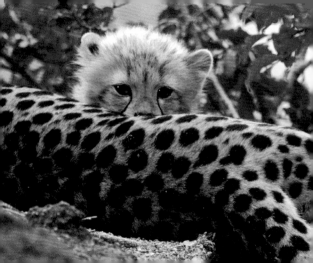

CHEETAH CUB

The cheetah *(Acinonyx jubatus)* takes motherhood seriously, and works hard to train her young to fend for themselves. By five weeks the cubs accompany their mother on hunts, studying her sprinting skills. They practise stalking, chasing and killing in play, emitting shrill calls if in danger, bringing their mother racing home. Weaned at three months, by six the youngsters are making their first kill, practising on small live rodents which their mother brings back for them. Practice makes perfect and by 15 months they're able to hunt their own prey.

CHEETAHS

The cheetah gives birth to three cubs on average, although she may have as many as eight, gestating for some three months. Like leopards, cheetahs hide away among rocks and scrub to have their litter, and are strongly protective. Once the cubs are fully grown, females are likely to remain in their mother's home range, while males may travel long distances before settling down in their own territories. Unlike their highly sociable offspring, adult cheetahs are generally solitary, although males sometimes associate in pairs or trios.

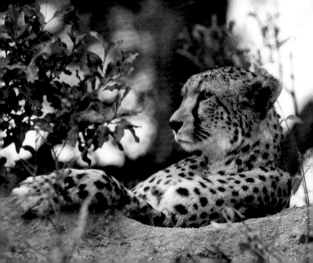

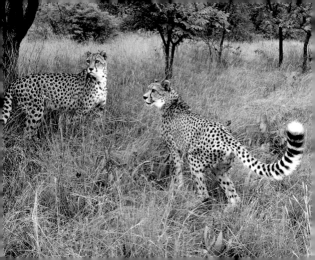

STEALTH, STYLE AND SPEED

The graceful cheetah combines stealth and supreme speed to capture its many varieties of prey, ranging from rats to wildebeest. It's the fastest living quadruped, reaching speeds of up to 112km/h over 300m. Its style is to stalk its prey to within striking distance, then to make an all-out sprint. If any victim stays the course, overheating forces the cheetah to give up. Generally, however, the chase ends with a sideswipe of the paw that bowls the animal over. Then the cheetah seizes its throat, severing the jugular vein with one swift *coup de grâce*.

GREVY'S ZEBRA FOAL

Found mainly in Kenya, Grevy's zebras *(Equus grevyi)* can be distinguished from other zebras by their narrow stripes, slender legs, long necks and the bull's eye pattern on their rumps. Mares give birth 13 months after conception, usually during the rainy season. The precocious Grevy zebra foal is able to stand a mere six minutes after birth. It can walk within half an hour thereafter, and can run short distances by the time it is 45 minutes old. Foals learn to graze as early as six weeks, and are weaned by nine months.

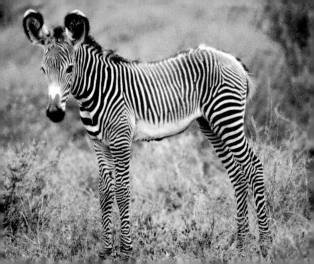

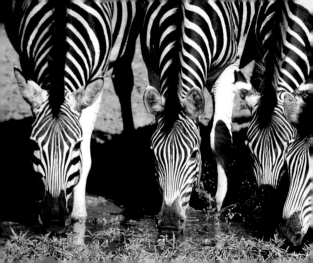

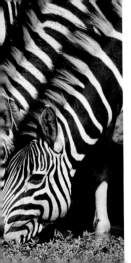

Burchell's zebra *Found in grassland habitats near water, these zebras* (Equus burchelli) *are active during the day, with midday visits to waterholes a routine activity. Zebras are sociable grazers and may be seen feeding in the company of wildebeest and gazelles. During nights they prefer to graze individually for short periods. While the rest of the herd sleeps soundly, a lone zebra remains alert, keeping an eye out for predators.*

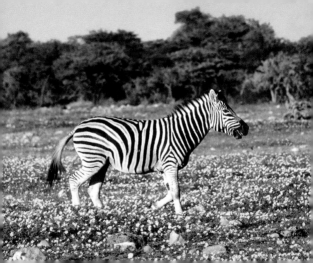

Burchell's Zebra

Questions about the purpose of the wondrous striped hide of the zebra continue to confound scientists. Chief among evolutionary theories is that the stripes confuse predators who see only a random pattern and are therefore unable to single out an individual. Another theory suggests that the markings act as camouflage – but zebra herds ranging in open grassland are startlingly visible, so that seems doubtful. Other theories are that the stripes create a 'feeling' of belonging among herd members, and that they help individuals recognise their own species.

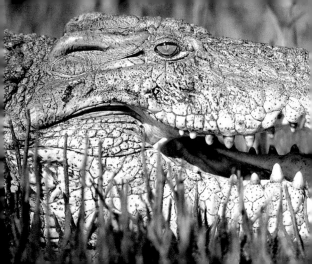

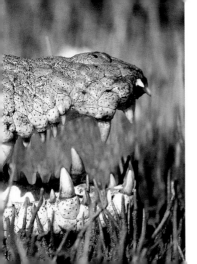

On the prowl

During the hunt, the Nile crocodile (Crocodylus niloticus) *lies patiently in wait before leaping out of the water, closing its enormous jaws over its prey's muzzle, and dragging it underwater to drown it.*

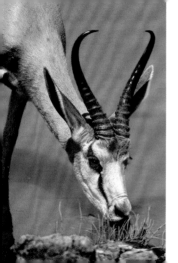

Leaping springbok

When alarmed, the springbok (Antidorcas marsupialis) *may arch its back and give a stiff-legged leap, known as 'pronking' (a form of stotting). It is able to leap as high as two metres before landing.*

Left *A springbok slakes its thirst at a waterhole.*

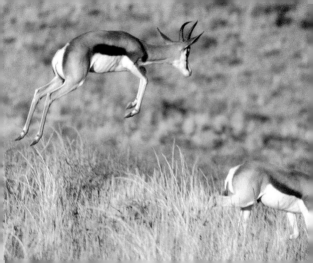

LOCKING HORNS

Springbok lock horns only occasionally, and more in fun
than fury – it's generally just a case of play-sparring
among young males, ending without injury. Yet springbok
rams are as territorially fierce in the mating season as any
other animal, and search their domain for a female herd
which they noisily round up. They are quite gentlemanly
about it, though. If a breeding herd chooses to move on,
the rams rarely resist. During the rut, though, rivals are
chased away, horns threatening. However, when mating is
over all is forgotten, and rams form bachelor herds.

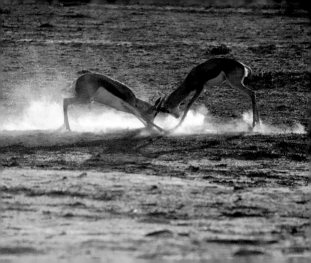

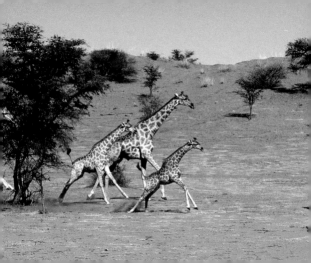

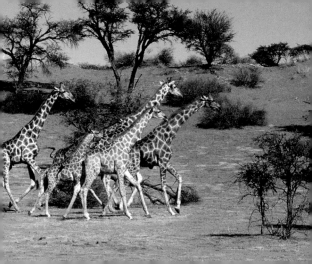

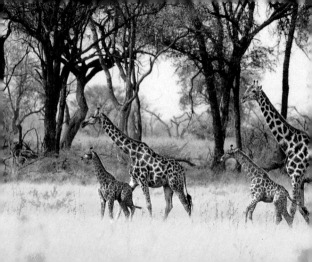

Giraffes These Goliaths of the African savanna are the world's tallest creatures, reaching nearly six metres in height. To sustain their 1,900kg bodies, giraffes (Giraffa camelopardalis) eat up to 34kg of leaves and shoots a day, which they pluck from lofty heights with tongues nearly 45cm long.

Previous page Galloping giraffes, Namibia.

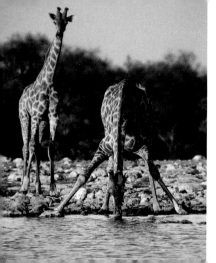

Gathering at the waterhole

Even after splaying its legs and bending its knees, the giraffe must lower its long, elegant neck five metres in order to quench its thirst.

Damara dik-dik *The small, shy dik-dik (Madoqua kirki) is able to survive for months without water by sipping dew and feeding on leaves, shoots and fruits.*

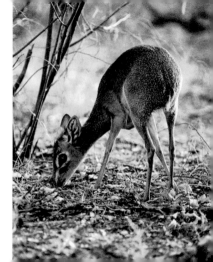

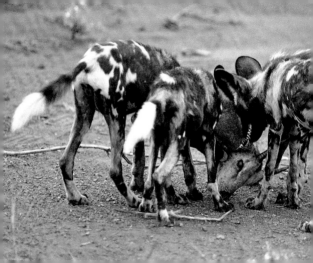

African wild dogs *The endangered African wild dog (Lycaon pictus) is regarded as one of the continent's most successful predators. Hunting in packs, the dogs, led by the dominant male, catch 85 percent of the quarry they chase. Once the prey is caught, the carcass is rapidly torn apart. Upon their return to the den, pack members disgorge meat for the pups and their mothers, and the sick.*

WATERBUCK

Water provides this handsome antelope with both sustenance and protection. Needing to drink nearly every day limits its range to a kilometre or two from a river or vlei. Though unpalatable to some predators, the waterbuck (*Kobus ellipsiprymnus*) represents a good meal to others – these it avoids by the simple expedient of plunging into the depths. Bull waterbuck, especially, are well able to defend themselves, using their magnificent, forward-curving, deeply ridged horns. Clearly visible here is the buck's extraordinary white-ringed rump.

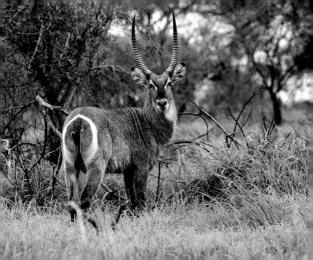

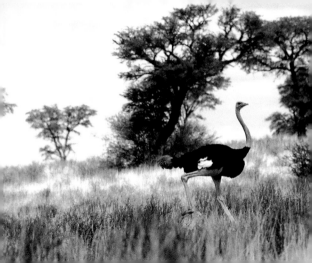

Ostrich *The world's largest living bird, the* ostrich (Struthio camelus) *can stand almost three metres high and weigh up to 150kg. These birds cannot fly, a feature they share with their relatives, the rheas, emus, cassowaries and kiwis.*

AFRICAN FISH EAGLE

No sound better captures the essence of Africa than the cry of the fish eagle *(Haliaeetus vocifer)*. Its call evokes the ancient plains of the African continent, slow, somnolent afternoons, the secretive rustle of savanna grasses under sunset skies and the sound of a jackal's howl echoing across moonlit valleys. No other sound is so paradoxical: haunting and forlorn, yet filled with the infinite possibilities of the unknown and the unexplored.

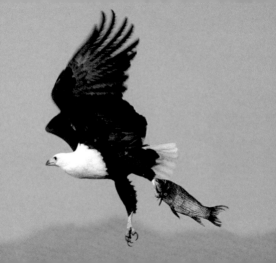

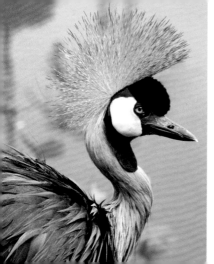

Crowned crane *The crowned crane (Balearica regulorum) prefers marshy habitats, where its straw-coloured crest blends in with the flower heads of surrounding sedges.*

Saddlebilled stork *Male and female saddlebilled storks (Ephippiorhynchus senegalensis) can be distinguished by the colour of their eyes: yellow in females and brown in males.*

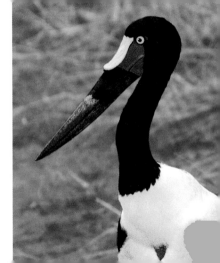

BLACK-BACKED JACKAL

The dog family has been evolving for some 54 million years. At its peak, around 26 million years ago, there were 42 genera extant. Now there are only ten, of which the jackal is one. For the sharp-witted and elegant black-backed jackal *(Canis mesomelas)* the chances of species survival are increased by the presence of 'helpers' – juveniles who remain to babysit the pups when the adults need to hunt for food. They also help feed lactating mothers and their litters by disgorging food. The more helpers there are, research shows, the more young survive.

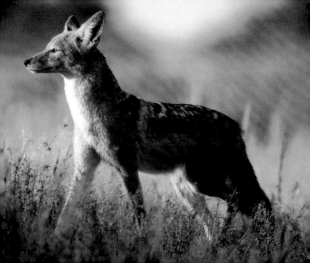

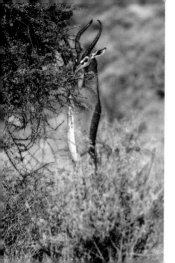

Gerenuk *The graceful gerenuk (Litocranius walleri), with its elongated neck and slender limbs, is perfectly adapted to feast on succulent leaves, shoots, fruits and flowers in the higher reaches of thorn trees and bushes. These rare creatures are found in the dry savanna regions of the Horn of Africa.*

Greater kudu *Tall and resplendent, the male kudu (Tragelaphus strepsiceros) sports a beard as well as his splendid horns, which continue to grow throughout his life. Kudu seldom fight, although it has been known for two rival bulls to be found dead, horns still locked.*

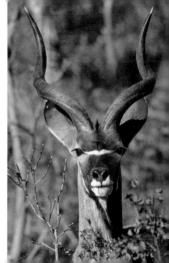

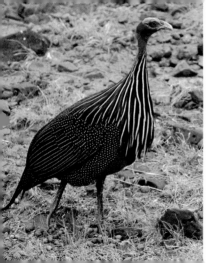

Vulturine guineafowl

The vulturine guineafowl (Acryllium vulturinum) is well adapted to the drylands of northeastern Africa, deriving all the moisture it needs from its food.

Serval *The slender, long-legged serval (Felis serval) is one of Africa's most elegant small cats. Seldom seen, it makes its home among tall grasses, near water.*

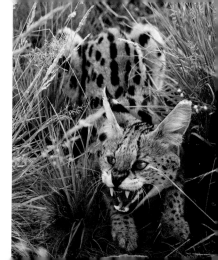

SCRUB HARE

Pausing briefly in the last golden rays of the setting sun, this shy scrub hare *(Lepus saxatilis)* forages for grass. During the day these nocturnal creatures shelter in 'forms' – shallow depressions which they shape with their own bodies. They lie in them with their ears folded back and their heads pulled into their furry bodies. Scrub hares are skittish, yet swift, often outsmarting their predators, leaping and zigzagging in all directions as they flee. They will even swim to avoid predation. This scrub hare feeds in the shrubland of Etosha National Park in Namibia.

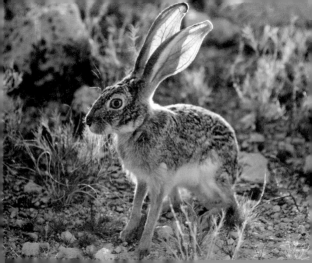

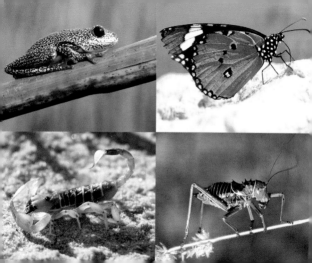

NATURE'S LITTLE GEMS

The thimble-sized painted reed frog *(Hyperolius marmoratus)* (top left), found in the Okavango Delta, clings to grasses swaying in the breeze. Like most butterflies, the delicate African monarch butterfly *(Danaus chrysippus)* enjoys only a few brief weeks of life (top right). Uniquely African, the ferocious-looking armoured ground cricket (bottom right) of the *Tettigoniidae* family is a nocturnal omnivore. The thin-tailed, less poisonous scorpions (bottom left) of the *Scorpionidae* family are also nocturnal, hiding under stones during the day.

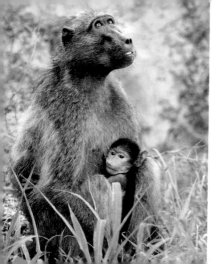

Chacma baboons

Found only in southern Africa, the highly social chacma baboons (Papio hamadrayas ursinus) *range in troops of between 10 and 100 individuals.*

Suckling suricate

Inhabitants of dry regions, the lively suricates or meerkats (Suricata suricatta) spend most of the day resting belly to the sun, socialising and foraging.

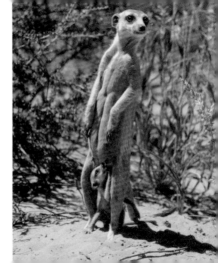

HIPPOPOTAMUS

Aquatic by day and terrestrial by night, hippos (*Hippopotamus amphibius*) submerge themselves in water and wallow in mud-pools to protect their sun-sensitive skins from dehydration and sunburn. After sunset, herds journey to adjoining grasslands to graze. During the five or six hours of supper time, adult hippos can walk up to 10km while foraging and consume 40kg of grass at one sitting. They traverse the same paths to and from their pasture every night and won't hesitate to attack any animal or human that comes between them and the water.

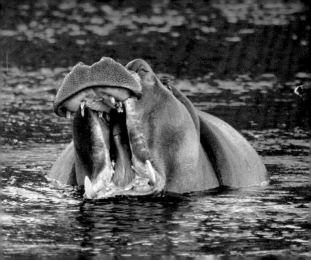

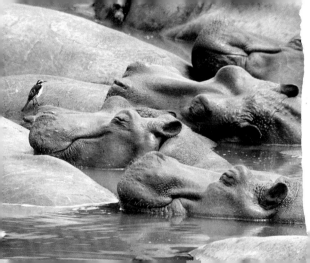

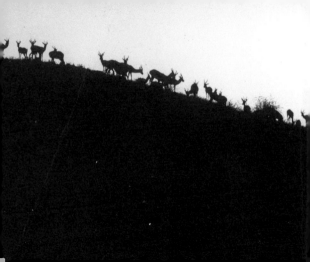